Vikings!

Highlights of the Exhibition

Gunnar Andersson

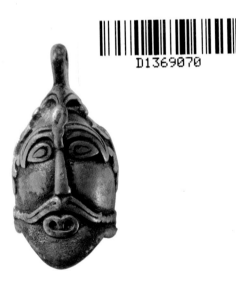

D1369070

National Museums Scotland

The Swedish History Museum

Museums Partner
www.museumspartner.com

Vikings!
The Untold Story

Exhibition at:
National Museum of Scotland
Chambers Street
Edinburgh EH1 1JF
www.nms.ac.uk/vikings!

18 January to 12 May 2013

The original exhibition is a joint venture between

The Swedish History Museum
Narvavägen 13–17
Stockholm
www.historiska.se

and

Museumspartner, Austria
www.museumspartner.com

with

studio exhibit, Austria
www.studio-exhibit.com

First published in 2013 by
NMS Enterprises Limited – Publishing
a division of NMS Enterprises Limited
National Museums Scotland
Chambers Street, Edinburgh EH1 1JF

www.nms.ac.uk

Text © Gunnar Andersson/The Swedish History Museum 2013
Images © The Swedish History Museum 2013
or as indicated

British Library Cataloguing in Publication Data
A catalogue record for this book
is available from the British Library.

ISBN: 978 1 905267 76 7

Cover design: Mark Blackadder
Cover image and title page: A pendant in the
 shape of a man's head, from Aska, Hagebyhöga,
 Östergötland (© The Swedish History Museum
 [SHM] 16560)
Publication format:
 NMS Enterprises Limited – Publishing.
Printed and bound in the United Kingdom by
 ARC Printing Ltd, West Calder, Scotland.

For a full listing of NMS Enterprises Limited –
Publishing titles and related merchandise:

www.nms.ac.uk/books

Contents

Foreword

MARIA JANSÉN

DIRECTOR GENERAL

SWEDISH HISTORY MUSEUMS, STOCKHOLM

The era of the Vikings is a mythical period in Scandinavian history, and the Vikings have become somewhat like international celebrities. In fact, apart from perhaps Abba, IKEA and Minecraft, they might even be considered one of our most well-known trademarks.

With the exhibition 'Vikings! The untold story' we aim to make this unique collection of artefacts accessible to an international audience and to share the opportunity to get up close to some of the most wonderful cultural treasures from this time. The different themes in the exhibition allow the visitor to dive deep into the Viking world – a world which has changed in recent years due to new research in the field. Previous conceptions and stereotypes are now being questioned and Vikings have shown themselves to be more versatile and fascinating than we have thus far understood.

'Vikings! The untold story' contains more than 500 original Viking artefacts from The Swedish History Museum's collection, including many that have rarely or never been exhibited outside Sweden, such as, for example, the silver crucifix that is thought to be the oldest known crucifix in Sweden.

The objects are highly revealing, informing us about life on the farm, the world of aristocrats and slaves, strong women, the importance of crafts, as well as travel and trade, and the transition between different religions. We welcome you to meet the new Vikings!

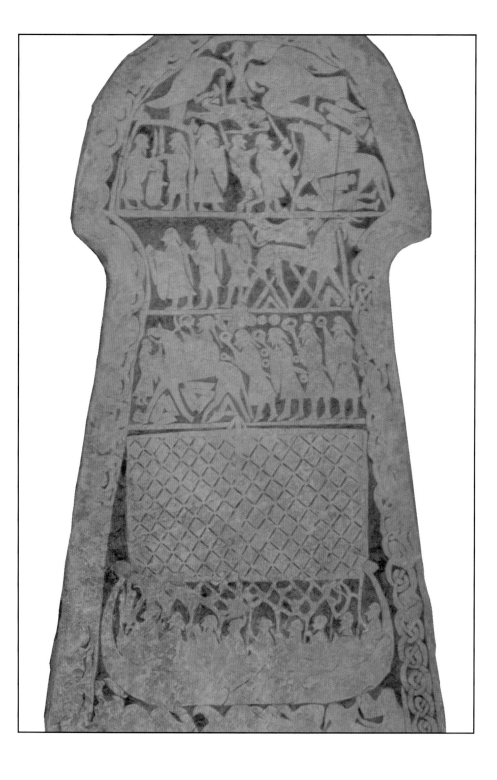

Introduction

We call them Vikings

What do we really know about the people that we today call 'Vikings'?

From a modern perspective, the 'Viking Age' is looked upon as a mythical period, not only within Scandinavia but also abroad. It is a time associated with violent raids, 'peaceful' trading, brave seamanship and colonization outside Scandinavia – and all of this conducted mostly by men.

However, our knowledge of the Viking Age has changed as a result of recent archaeological discoveries. These are further assisted by related disciplines in the social sciences, such as history and linguistics.

A period of unclear borders

Although Scandinavian archaeologists invented the term 'Viking Age' during the 19th century, the dating of the beginning and end of the period is a more recent invention. From a historical perspective, the Viking Age began in AD 793 with the attack by 'Norraener' (Norse) men on the monastery at Lindisfarne in the northeast of England and ended at the battle of Stamford Bridge, Yorkshire, England, in 1066. From a Scandinavian point of view, it might appear odd that the Viking Age is historically defined by events that took place in the British Isles.

**Opposite:
Picture stone**

Found exclusively on Gotland, picture stones show mythological scenes. Here a warrior's journey to Valhalla is illustrated (see page 40). Dated 8th–9th century AD, this stone comes from Tängelgårda, Lärbro, Gotland.

Below: Penannular brooch (silver)

Typical of the Viking Age period, this brooch is decorated with punctuated triangles and octagonal-shaped terminals in the same style as Arabic weights. From Lilla Klintegårda, Väskinde, Gotland, Sweden.

Images: The Swedish History Museum (SHM 33763, 5804)

Today it is understood that the period of the Viking Age can be defined in different ways, depending upon what is being studied and how the evidence is approached. It is known that Scandinavian travellers were taking goods and knowledge of foreign lands home with them long before the events that took place at Lindisfarne. Archeological evidence further suggests that Viking journeys were following already established shipping lanes.

There may also have been instances of looting and violence at that time, although there are no historical sources to support this.

Who or what was a 'Viking'?

The word 'viking' appears on rune stones and in written (Old Norse) sources. It has a number of definitions, but is mostly used to describe a situation or an activity. Men, women, youths, even children, could all have gone out on 'a viking' – meaning a commercial trip or raid. In other words, people did not refer to themselves as a Viking unless they were on 'a viking'.

So what *did* they call themselves? This is not really known, but individuals possibly used their farm or village names, in the same way that someone living in London is called 'a Londoner', and so on. In the written sources, the term 'Norraener menn' (Norse men) was used as a designation for all Nordic peoples, except the Sami in the northernmost parts of Scandinavia.

Expanding across Europe

Between *c.*AD750 and 1100 many people left Scandinavia on trading or raiding expeditions, or to settle in new parts of eastern and western Europe.

In the 8th century, Scandinavians known as the Rus moved into what is now north-western Russia, which they called Gardariki. This was the beginning of further travels eastward, to the countries beyond the Black Sea and the Caspian Sea, to Byzantium and to what is now the Middle East.

Towards the end of the 8th century, raids are recorded for the first time in the Frankish Empire (modern-day France), and in the British Isles and Ireland. Improvements in ships and sailing technology went hand-in-hand with these new expeditions. Viking fleets sailed down the Iberian Peninsula and into the Mediterranean, and along the journey they attacked both European and North African destinations.

While some Norse settlers encountered resistance from local people, others made alliances or married into local communities, losing their distinct foreign identity in the process.

Major Norse settlements soon grew into important trading centres. From Cork to Kiev, these centres transformed the lives and economies of those in the surrounding areas. Some would become the foundation of major cities and ports – such as Dublin, for example, which became the capital of Ireland.

Meet the Vikings

So, who were the Vikings, how did they live, and what did their world look like? This exhibition uses new archaeological evidence to provide answers to some of these questions.

A number of different themes are explored to provide an insight into domestic life, family and community, the rituals that surround death, the significance of crafts, the power of mythology, and the symbolism of the Viking ship. By investigating these themes, it is hoped that existing stereotypes can be removed and that the 'Vikings' will appear to audiences today in a more subtle and fascinating light than ever before.

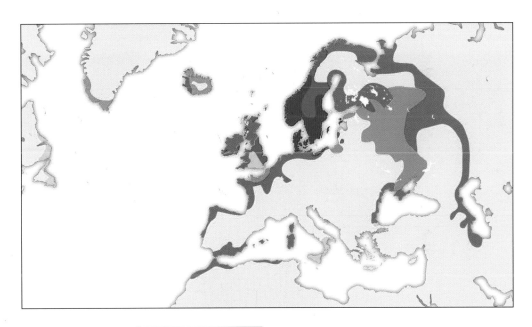

Key: Scandinavian settlement

- 8th century
- 9th century
- 10th century
- 11th century
- Frequent Viking raids, but little or no Scandinavian settlement

Map of Viking activity and Scandinavian settlement, 8th–11th centuries

This map shows the wide extent of Viking activity and Scandinavian settlement across Europe and the North Atlantic in the period from the 8th to the 11th centuries.

The Swedish History Museum

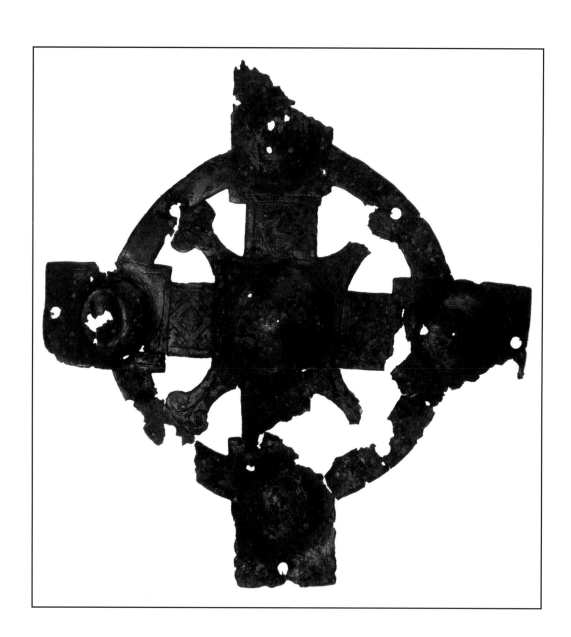

Exotic goods and cultural influences

Viking activity stretched from the Orient in the east to Greenland and North America in the west; from the islands far to the north in the Atlantic, to the distant Mediterranean and North Africa in the south.

During this time, exotic and luxury goods flowed back to Scandinavian homelands and were made available, to those who could afford them, at trading posts such as Birka, Hedeby, Kaupang and others. Along with the material goods came a flood of new political ideas and religious beliefs.

Some objects bear witness to contact with many communities during the Viking Age. Examples featured here and on pages 12–13 include a Frankish beaker, an Irish cross, a Buddha figurine from India, a Coptic ladle from Egypt, a necklace made from oriental beads of carnelian and rock crystal intermingled with native beads, and shells from the Red Sea and Indian Ocean that were used in the manufacture of pendants.

Meetings between the Norraener men and other people led to changes in Scandinavian societies. Over time, many external influences contributed to objects, belief systems and ideology taking on other shapes and forms of expression.

Opposite:
1. Cross (bronze and tin)

Of Irish origin and made from a bronze plate with engraved decoration. A find from a grave at Birka, Adelsö, Uppland, Sweden.

The Swedish History Museum (SHM 34000:Bj 511)

Right: 2. Buddha figurine (bronze), 6th century

Figurine of Buddha from the Swat valley in the northern part of the Indian sub-continent. It was found in Helgö, Ekerö, Uppland, Sweden.

The Swedish History Museum (SHM 29750:476)

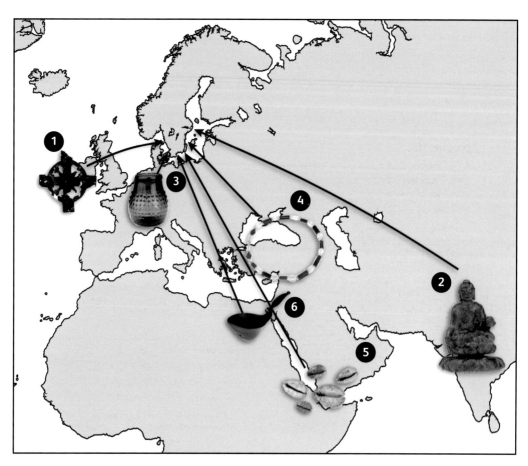

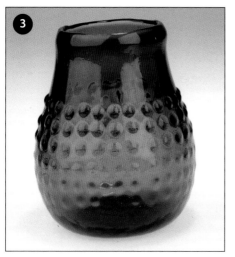

Opposite: Map

A map showing each object in the place it originated from. The arrows indicate that each object travelled a long way to the place of its eventual discovery in Sweden.

Map by Kerstin O. Näversköld, The Swedish History Museum

1. Cross (bronze and tin)

Cross of Irish origin from a grave at Birka, Adelsö, Uppland, Sweden (see page 10).

2. Buddha figurine (bronze), 6th century

Figurine of Buddha from the Swat valley in the northern part of the Indian sub-continent, found in Helgö, Ekerö, Uppland, Sweden (see page 11).

3. Beaker (replica)

The original grape beaker, from Birka, Adelsö, Uppland, Sweden, is of Frankish origin.

4. Beads (rock crystal and carnelian)

These beads originate from the Black Sea area and were found in a grave in Birka, Adelsö, Uppland, Sweden.

5. Cowrie shell

Imported cowrie shells were sometimes worn as pendants. This example is a grave find that originally came from the Red Sea, Egypt.

6. Ladle (replica)

The original is believed to have been used in ceremonies within the Coptic church. It was found in Helgö, Ekerö, Uppland, Sweden.

Images: The Swedish History Museum
(SHM [1–6] 35000:Bj511, 29750:476, 29760:474, 34000:Bj 507, 5208:2515 and 24785:1410)

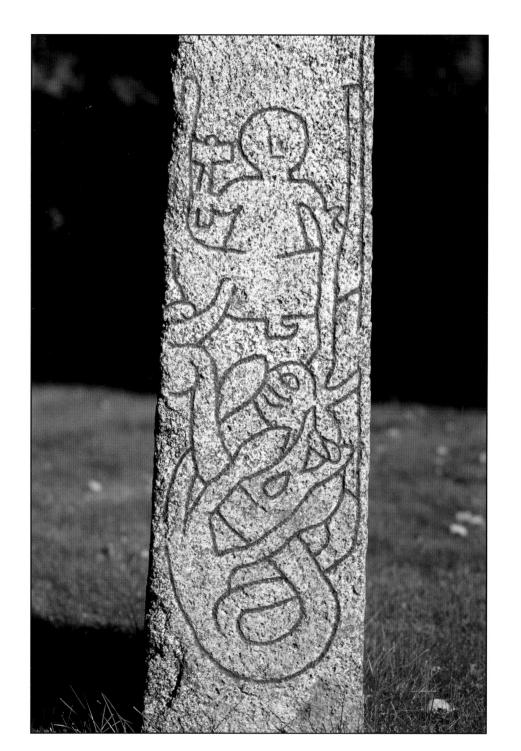

A complex culture

… with wide variation

A single Viking Age culture shared by every individual across Scandinavia never actually existed. Viking studies, originating in the 19th century, used elements of language, art, mythology and gods to present a uniform Viking Age culture, but closer examination reveals wide regional variation.

This variation is sometimes expressed through, amongst other things, jewellery design, fashion and burial practices. Place names bearing the name of a god or goddess (so-called 'theophoric' place names), the popularity of individual gods and the practice of religion also reflect significant regional differences.

Early written sources refer to *forn siðr*, an Old Norse term for ancient religious practices, relating to all aspects of life and death.

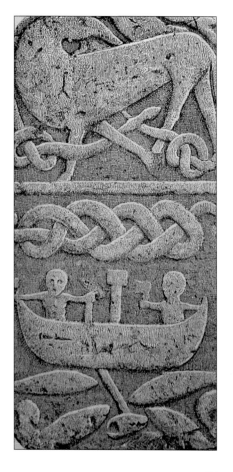

Opposite: Altuna stone, Uppland, Sweden
Right: Stone at Gosforth, England

Thor's fishing expedition, as depicted on the Altuna rune stone from Uppland (opposite), shows regional variation when compared with the stone panel at Gosforth, England (right).

Runestone U1161 (detail), parish of Altuna, Uppland, Sweden. Photograph: Bengt A. Lundberg 1985. Copyright: National Heritage Board, Sweden.

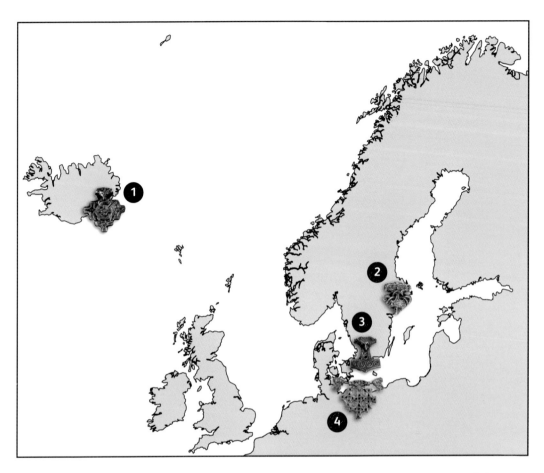

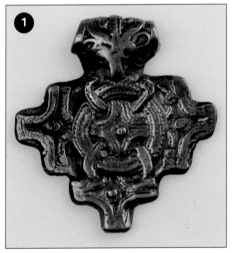

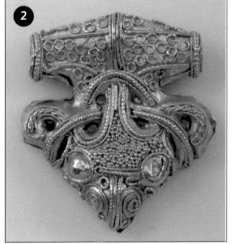

Mythical animals and birds of prey

Evidence for common forms of art and shared mythology during the Viking Age can be found across Scandinavia, but again there are many regional variations.

Mythical animals were widely used in the decoration of brooches, pendants and other jewellery. The 'gripping beast' style (see object 4), with interwoven figures in tight patterns, also appears on many objects (see pages 46–47). Another favoured design is the head of a bird of prey (see object 3).

Opposite: Map

A map showing where each object comes from –
1. Iceland, 2. Sigtuna, 3. The Mälaren Valley, Scania and 4. north Germany.

Map by Kerstin O. Näversköld, The Swedish History Museum

1. Cross-shaped pendant (silver) (replica)

The original, now in the National Museum of Iceland, was found in Iceland.

2. Pendant (gold, filigree ornamentation)

From Sigtuna, Uppland, Sweden.

**3. Thor's hammer pendant
(silver, filigree ornamentation)**

Unknown find-spot, Scania, Sweden.

4. Pendant (gold) (replica)

The original was found as part of the Hidensee treasure, Pommern, north Germany.

Images: The Swedish History Museum
(SHM [1–4] 29750:22, 27883:1, 9822:810 and 9821)

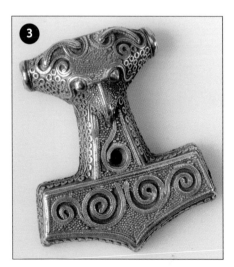

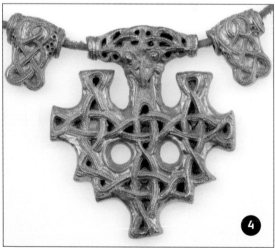

Regional differences

Although people across Scandinavia had much in common – often expressed through language, art and mythology – archaeological evidence reveals many regional differences. Women's fashion and jewellery collections share some broad similarities across the different regions of Scandinavia, but there are still some distinct regional variations.

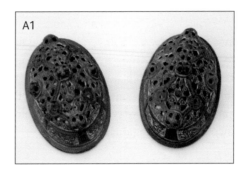

A1

In the 9th–10th centuries, women of high status often wore gilded brooches and colourful beaded embroidery. The traditional look consisted of two brooches pinned to the fabric that held up the dress. One or more strings of beads were hung between the brooches. The opening of the blouse or the shawl

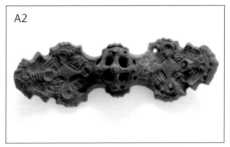

A2

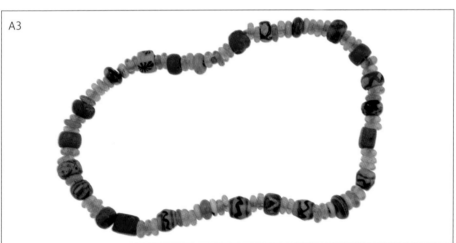

A3

A1 Oval brooches (bronze, gilded, iron, textiles)

Used to hold up a woollen over-dress. A grave find from Birka, Adelsö, Uppland, Sweden.

The Swedish History Museum (SHM 34000:Bj 566)

A2 Equal-armed brooch (bronze, iron and textile)

This brooch is typical of the Swedish mainland. A grave find from Birka, Adelsö, Uppland.

The Swedish History Museum (SHM 34000:Bj 1081)

A3 Beads (glass)

These glass beads from a grave in Birka, Adelsö, Uppland, hung between two oval brooches.

The Swedish History Museum (SHM 34000:Bj 1081)

across the shoulders was held together below the neckline by a third brooch.

However, while women in Scandinavia typically used a pair of oval brooches to hold up their dress (A1) and a rectangular equal-armed brooch (A2) as their third brooch, the women on the island of Gotland in present-day Sweden had their own distinctive regional style.

They preferred a pair of triangular brooches (B1) in the shape of an animal's head, in combination with a box-shaped brooch (B2).

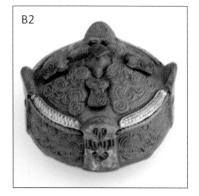
B2

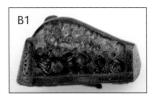
B1

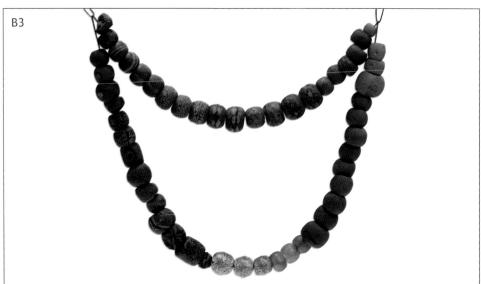
B3

B1 Animal-headed brooches (bronze, silver, gold)

These brooches, worn in pairs on the chest area of a woman's clothing, are typical of Gotland.

The Swedish History Museum (SHM 4814, 4645)

B2 Box-shaped brooch (bronze, silver)

Exclusive to Gotland, this grave find from Hemse, Annexhemman, held a cloak, scarf or coat together.

The Swedish History Museum (SHM 4683)

B3 Beads (glass and gold)

This set of beads, part of a hoard found in Petes, Linde, Gotland, includes three golden beads.

The Swedish History Museum (SHM 13441:1–3)

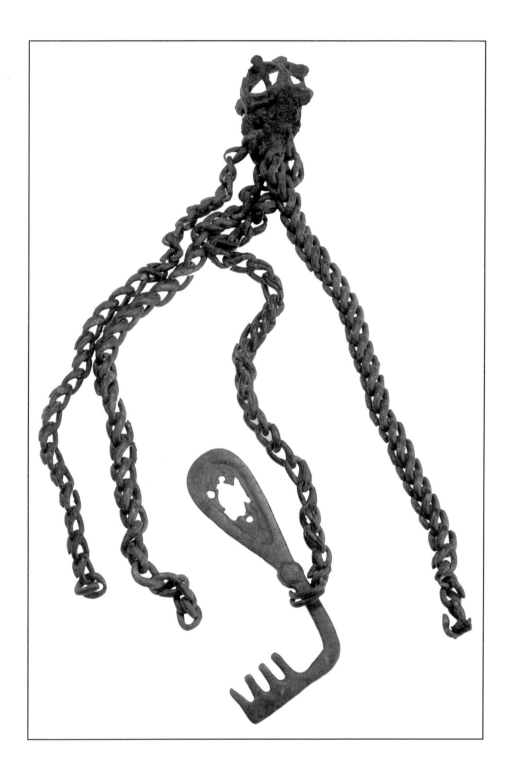

The structure of society

Land, family and farming were at the heart of Viking society. Owning land was very important and determined your social position, your history and your future. The extended family was the basic community on the farm. A person first and foremost belonged to a family group, with responsibility for that family's actions.

The Viking Age is often presented as a very hierarchical period, where a person's position in society was limited to the class into which they were born. This overview of Viking Age society is, to a great extent, taken from *Rigstula*, an epic poem found in the older literary work, *The Poetic Edda*. *Rigstula* describes how the god Heimdall (called Rig in the poem) visited three different families, all couples, while journeying through the world of humankind. Each couple represented a different social class and together they represented society as a whole.

The couples played host to Heimdall/Rig over three consecutive nights. Nine months later the women gave birth to sons. The babies were given the names Träl (thrall), Karl and Jarl, representing thralls (the unfree or slaves), the free, and the aristocracy respectively. As Heimdall/Rig was father to them all, the social structure of society and its characteristics were given divine legitimacy.

Rigstula 's view of society is stereotypical. The reality was not so clear-cut. Viking Age society was hierarchical, but in many ways social positions were not as rigid as we might imagine. Opportunities for an individual's advancement, as well as loss of status, were always possible.

Opposite:
Tool brooch with chain and a key (bronze)
Household tools hung from this brooch. It was fastened onto the chest area of women's clothing. A grave find from Stora Ire, Hellvi, Gotland, Sweden.

The Swedish History Museum (SHM 22917:232)

The greatest difference between people was that which existed between the free and unfree. If the Early Medieval texts of law are to be believed, freemen (karls) had the right to bear weapons and to make their voices heard at the Thing (a regional assembly where different kinds of disputes were settled); unfree men (thralls or slaves), however, had no rights at all.

However, even this definition is too simple, as illustrated by the various terms for 'unfree' that appear in the Old Norse sources. While some unfree were considered purely labour slaves, others had significant rights bestowed upon them. An unfree 'housecarl' on a farm or estate could, if he was lucky, advance to the level of 'bryte', a type of farm manager or overseer who supervised the work of others.

Adze (iron)

This tool was used for timber-working. From Unsarve, Halla, Gotland, Sweden.

The Swedish History Museum (SHM 9507)

Fetters (iron)

Found at Skedala, Snöstorp, Halland, Sweden.

The Swedish History Museum (SHM 11773)

The unseen unfree

A large proportion of the population was unfree – that is, thralls. How large a proportion is unclear. Various studies have indicated figures of between 20–40 per cent of the total population, although evidence suggests that regional variation existed.

Different terms for the unfree are found in the written sources. 'Ambátt' and 'þræll' are collective terms for unfree females and unfree males respectively. There were also distinctions based upon the kind of task each individual carried out, and whether the thrall had been conquered or was born locally. The latter, known as 'fostri' (male) or 'fostra' (female), had more freedom than those who had been conquered and forced into captivity.

Evidence of thralls and the unfree are difficult to locate in the archaeological record.

Millstone

The axis was placed in the middle of the stone, to turn the mill and grind the grain.

The Swedish History Museum (SHM 13301)

Over the years researchers have assumed that unfree people were not entitled to own property and thus looked no further, perhaps adding to their anonymity.

The presence of thralls is more likely to be found in the objects they produced, the tools they used, and evidence of their work, such as the monotonous and heavy labour of grinding grain. Indeed a thrall's hand may be detected behind a number of basic tasks, such as food production and preparation.

A few finds of mutilated or executed people, often thrown into the graves of other individuals, may also provide evidence of thralls.

The trade in thralls or slaves for labour was highly profitable. Indirect evidence of the trafficking of thralls in Viking Age Scandinavia has emerged in archaeological finds such as shackles, neck-irons and other chains.

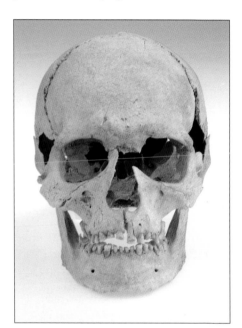

Left: Cranium, male

The teeth show proof of harsh living conditions. Worn teeth may have been due to a diet that included lots of bread containing small parts of sand or stone from the grinding process. It is not known whether this individual was free or unfree.

Below: Human vertebrae

Traces of compression injury and leakage of the cartilage of the dorsal vertebrae indicate hard physical labour.

Images: The Swedish History Museum
(SHM 29352 and 23896)

Right: Human bone

There are signs of osteoarthritis on this bone, indicating that the individual had been engaged in hard physical labour.

The Swedish History Museum
(SHM 23248)

Strong women

Many believe that the Viking Age was a male-dominated era – one in which men in warships fought, raided monasteries, or set out on long trading voyages, while the women stayed at home on the farm, spinning and weaving. However, archaeological and written sources paint a very different picture. Artefacts in Viking Age graves often symbolize the different social roles of men and women. They also show that there were rich and powerful people of both genders.

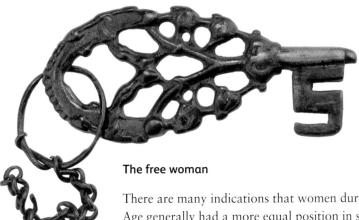

The free woman

There are many indications that women during the Viking Age generally had a more equal position in society than they later came to have. Rather than the male-dominated hierarchies of the Medieval period, the relationship between the sexes during the Viking Age seems to have been more complementary, with the contribution made by women to reproduction no less valued than that of men.

Family relations could be traced through both the father's and mother's lines. It was also possible to marry above your station in society, and this seems to have been a strategy adopted by many men who climbed the social ladder by

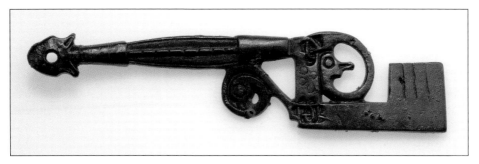

marrying rich widows or heiresses. Such men then laid claim to their wife's land and power. A position of increased authority could be attained this way, especially in aristocratic society.

For women, the role of Lady of the House was a powerful one. From a modern-day perspective, women being responsible for the home instead of having public duties may be seen as a sign of their limited power, but the farm was the centre of Scandinavian society and thus of vital importance.

Keys

Keys are a common find in Norse graves. Many iron examples are well-worn and intended for practical use. However, some female graves contain unused bronze keys, often with decorated shafts. A key was one of the most obvious symbols of the powerful role of Lady of the House. It would have been worn, fully visible, on the outside of a woman's clothing.

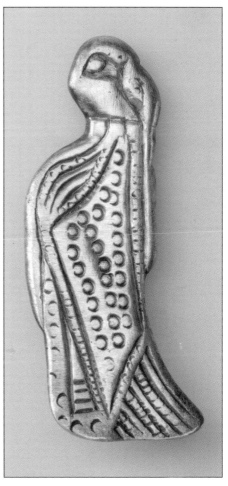

Above: Key (bronze)

A grave find from Stora Ire, Hellvi, Gotland, Sweden.

The Swedish History Museum (SHM 22917:183:1)

Pendant, female figurine (silver)

This figurine of a female is thought to be a Valkyrie (see pp. 44–45). From Sibble, Grödinge, Södermanland, Sweden.

The Swedish History Museum (SHM 20672)

The role of women

Women had many roles to play during the Viking Age. Norse literature reveals that they were sometimes involved in activities more normally associated with men, such as trade or colonization. Some could even afford to pay for rune stones to be erected. Used to commemorate the dead or to mark an event, these stones were a highly public act on a grand scale. This indicates that some women had, or could acquire, the social standing to act independently, possibly through widowhood or inheritance.

Although the women behind these rune stones are mostly named as mothers, daughters, wives or sisters to the men whose memory is being honoured, it is often possible to guess the important roles held by these women. Some, for example, seem to have taken over the role of master after the death of their husbands. The rune stone in the picture below has

been carved in a shape symbolic of a bowler chair (kubstol) or seat of honour. The inscription reads: '*Stenhild had this stone erected in memory of Vidbjörn the journeyer to Greece, her husband. May God and God's mother help his soul. Åsmund Kåreson carved.*'

The multi-faceted role of women becomes even more apparent in the case of aristocratic women, who appear to have had a close connection to the real-life clairvoyant Völur, as well as the mythological Norns and Valkyries (see pages 28, 39, 44–45). The boundaries between them are often blurred, as aristocratic women were also thought to be able to predict the future and to manipulate destiny.

In Old Norse literature, aristocratic women also acted as a kind of keeper of social memories and were often presented as the uncompromising guardians of

Rune stone

Rune stone U956, Vedyxa, parish of Danmark, Uppland, Sweden.

Photograph: Bengt A. Lundberg 2009. Copyright: National Heritage Board, Sweden.

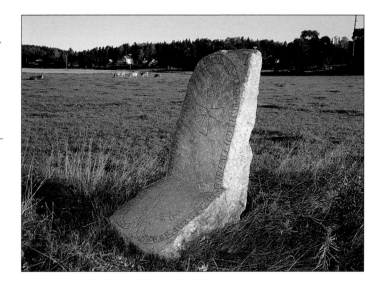

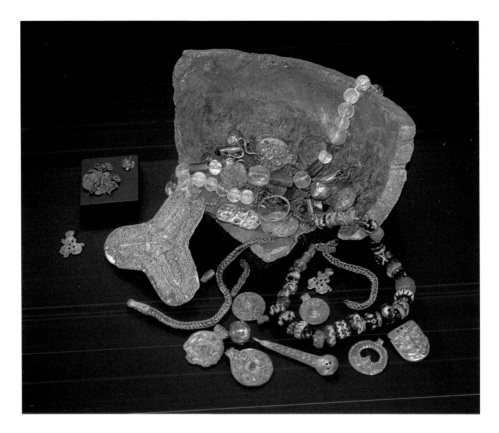

their husbands' honour, remembering injustices, instigating revenge, and so on. Although these were devices created to suit the stories, they also tell us something about how women were perceived.

Being a keeper of social memories could also mean that women of rank were the bearers of tradition in a broader cultural sense. A particular type of silver hoard, such as that found at Färgelanda, may be associated with such influential women. The contents are organized thematically around one or more pieces of 'female jewellery' (such as the bead embroideries and the trefoil brooch), with the composition of the hoard often having much in common with those

from the earlier eras of the Iron Age (5th and 6th centuries AD).

Artefacts in hoards such as Färgelanda do not consist solely of silver and are not generally broken, a feature that characterizes many other silver hoards (referred to as hacksilver hoards).

The Völur

A special role for women was that of the Völva, a *seiðr* or a kind of seer who was able to enter into a trance. It was also believed that she could predict the future, a quality shared with the Old Norse goddess Freyja (see page 43). The Völur and their deeds are described in mythological contexts, such as the prophecy of the Völva in the Voluspá section of *The Poetic Edda*, as well as in the more narrative saga of Erik the Red. She is presented in both sources as a respected, even revered, woman.

The Völva carried a distinctive staff that she used during her visions. The word 'völva' means 'staff carrier' in Old Norse. In the saga of Erik the Red, it is further noted that she wore gloves and a hat lined with cat fur – again a reference to Freyja, as the cat was her sacred animal. The Völva sat in a bowler chair, a seat of authority, while prophesying the future.

It is often questioned whether the Völva was a real person or fictional character of literature and mythology. A type of iron staff, thought to have belonged to a Völva, has been found in the graves of women. The staffs are decorated with a basket-like attachment at the top and bronze knobs on the shafts.

Several of these graves are richly endowed, with many unique artefacts. From this it can be concluded that the Völur had a number of different roles in society, as well as religious or magical powers. They were certainly not 'witches' confined to the fringes of society.

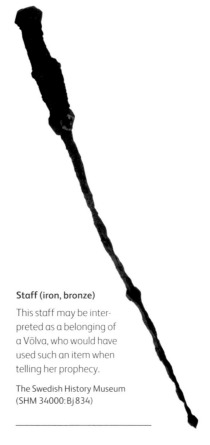

Staff (iron, bronze)

This staff may be interpreted as a belonging of a Völva, who would have used such an item when telling her prophecy.

The Swedish History Museum (SHM 34000: Bj 834)

Figurine in the shape of a cat (amber)

From Birka, Adelsö, Uppland, Sweden.

The Swedish History Museum (SHM 8252:1)

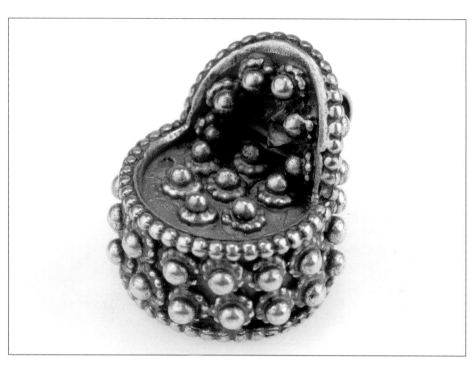

Above: Pendant shaped like a bowler chair (kubstol) (silver) (replica)

The original is a grave find from Birka, Uppland. Sweden.

The Swedish History Museum
(SHM 29750:490)

Left: Pendant shaped as a bowler chair (kubstol) (amber)

Bowler chairs were made of a single piece of wood, possibly symbolizing the throne of a Völva. From Barshalder, Grötlingsbo, Gotland, Sweden.

The Swedish History Museum (SHM 32181)

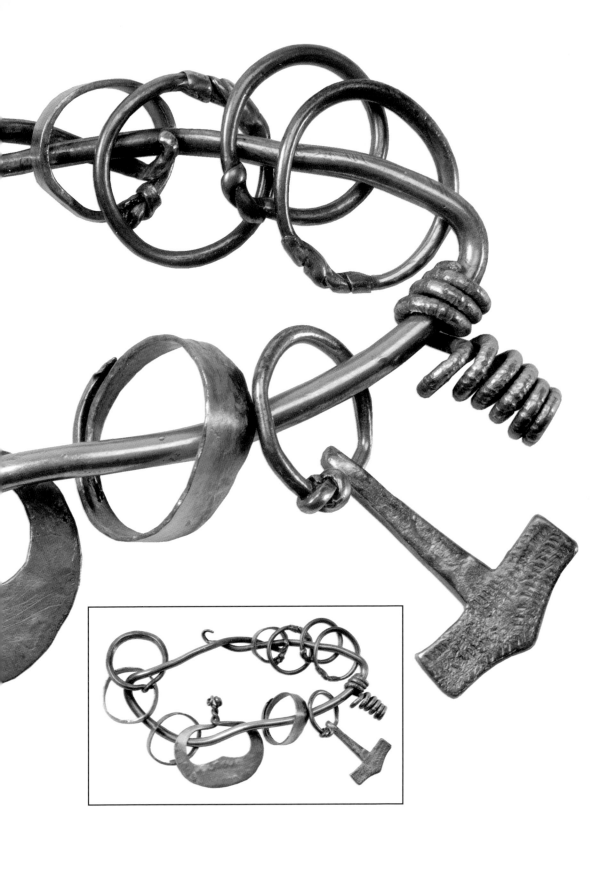

More than
just worship

A time of religious change

At the beginning of the Viking Age, AD 750–800, Christianity had already been established in many parts of continental Europe for several hundred years. During the following centuries, Christianity became increasingly important in the North, and towards the end of the Viking Age, around 1100, it had become the universal religion in Scandinavia, at least in an official sense, although older practices still survived.

During most of the Viking Age, however, people in Scandinavia had two very different religious systems they could adhere to – the older, indigenous pre-Christian/Old Norse religion (popularly known as the Aesir Faith), as well as Christianity. On many occasions the two appear to have been merged together into a kind of religious fusion.

There were substantial differences between the two types of religion, the most obvious being that people in Viking Age Scandinavia worshipped many gods and goddesses. Old Norse religion was characterized by cult worship and ritual that reflected the focus of society on family and lineage. In contrast, Christianity is the worship of a single god through a universal religion of salvation based on doctrine and dogma. Religious change was accompanied by social change, with Christianity stimulating a more patriarchal and hierarchical society.

The first Christian rulers in Scandinavia, backed by the Church, assumed new rights and became stronger. One supreme god provided a divine model for one supreme king. The Old Norse beliefs became less important and were abandoned by those in positions of power.

Opposite: Amulet ring (silver)

The pendants represent Norse gods Thor, Odin and Freyr. From Öland, Sweden.

Below: Pendant, crucifix (silver)

Thought to be the oldest known crucifix in present-day Sweden, it was found in Birka, Adelsö, Uppland.

Images: The Swedish History Museum (SHM 7589 and 3400:Bj660)

Thor's hammer and the Christian cross

Christian and pre-Christian (Old Norse) beliefs were often merged together. The results of this merger appear not only in Norse written sources, but also on objects and artefacts.

Old symbols, such as the Aesir god Thor's hammer and triquetra (an almost universal symbol for infinity or eternity), have occasionally been found on various types of pendants and brooches alongside the Christian cross. New and old symbols could be combined on the same object and perhaps given a new meaning that fitted the particular context or environment in which the object was used.

On other occasions, combinations of symbols might be found on objects worn at the same time – such as in a set of 35 gilded pendants and a box-shaped brooch from Gotland (opposite, above). The fish-head shaped pendants are all adorned with crosses. This may refer to the Christian symbol of the fish. The box-shaped brooch, however, in addition to the crosses, displays the gripping beast style that is based on Old Norse tradition.

The woman who once wore this amazing array would almost certainly have been able to interpret and understand the meaning of the radically different symbols on her jewellery and the shape of the pendants.

The majority of Scandinavians were probably acquainted with Christianity, even if they did not think of themselves as Christian.

Above: Pendant
(bronze and white metal)

From Roma, Gotland, Sweden.

The Swedish History Museum
(SHM 11353)

Opposite, above:
Box-shaped brooch and set of pendants (bronze, gold, silver)

A hoard find from Krasse, Guldrupe, Gotland, Sweden.

The Swedish History Museum
(SHM 6387)

Opposite, below:
pendants, cross-shaped

The silver pendant (left) is made from a coin.

The Swedish History Museum
(SHM 3400:Bj660 and 8064:197)

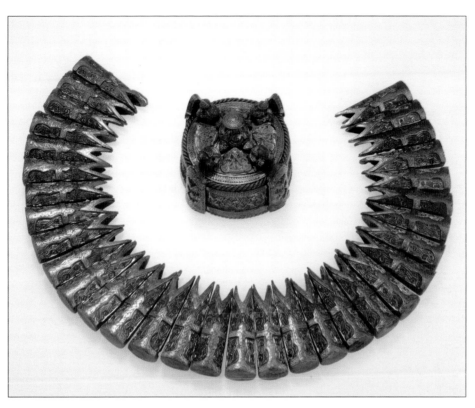

The interpretation of symbols

Like the fish, the hart was a symbol of Christ in the early Church. The symbolism is found on certain types of brooch and there is a rare survival on a very beautiful textile from Birka – a hart embroidered with silver thread on silk fabric. The textile fragment and motif are from clothing, probably a cloak or jacket. There is a small triangular white stone embroidered into the hart that marks its heart. It is difficult to imagine how beautiful this cloth must have been. The silver may have oxidized and darkened, but it would have glimmered white in its original state, perhaps recalling the 'White Christ', as Christ was referred to in Scandinavia.

On a particular type of round silver brooch the hart is always found in set combinations. Never alone, it is usually accompanied by three other harts. The harts are gathered around what appears to be a well or a mountain from which four rivers gush forth. It has been suggested that the well is the 'well of life' and the mountain with its rivers a symbol of the four rivers of Paradise. The composition may perhaps represent verses from Psalm 42 of the Book of Psalms.

As the deer pants for streams of water, /
So, my soul pants for you,
O God.

My soul thirsteth for God,
for the living God: / When
shall I come and appear
before God?

This psalm was read during the most important moment of the Christian year, the Easter Vigil, when new converts were accepted into the Christian community.

Embroidery (silver on silk textiles)

The image shows a stag turning its head. Found in a grave at Birka, Adelsö, Uppland, Sweden.

The Swedish History Museum (SHM 34000:Bj735)

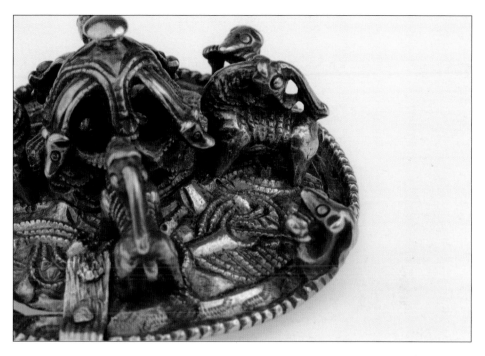

Detail (above) of a round brooch (silver) (below)

From Väsby storgården, Skå, Uppland, Sweden.

The Swedish History Museum (SHM 246)

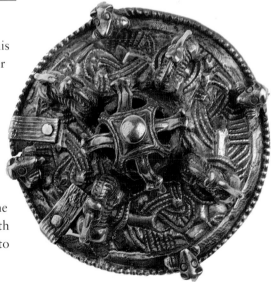

It has been noted that the harts on this silver brooch (right), just as on the silver embroidered fabric opposite, are looking backwards, anxiously perhaps, as if worried by something. Indeed, behind them there appear four rather predatory creatures, ready to attack with forepaws raised. How this scene should be interpreted is unclear. Could it perhaps be a stylistic rendering of the Christian mission and its struggle with pre-Christian beliefs, or is it referring to another biblical passage entirely?

Relics and legends

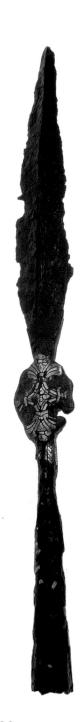

Veneration and the sale of relics soon became a central part of Christian practice, which quickly gained a foothold even in the newly Christianized Scandinavia. Parts of the skeletons of holy people (saints) or objects which, in one way or another, could be connected to Christ, were kept in special boxes (reliquaries) or in capsules or hollow crosses/crucifixes known as encolpia. These reliquaries or encolpia were mostly made out of precious metals, such as silver or gold. Encolpia were worn around the neck.

The large reliquary from Cammin (Kamién Pomorski) in Poland is a magnificent example (opposite, below). It was made in the AD 1000s, in the shape of a Viking Age longhouse. Created from 22 large sheets of elk antler, it was ornamented in the Mammen style (see pp. 46–47) and assembled using gilt bronze fittings. According to legend, the king of Norway, Sigurd Jorsalafar ('The Crusader'), received the box as a gift from Eric Emune ('The Memorable'), king of Denmark. Sigurd stored a piece of Christ's cross in the reliquary which had been discovered during a pilgrimage to Jerusalem in the Holy Land in AD 1110. He later donated the reliquary casket to the Kastala church in Kongahälla in western Sweden.

During the 1130s, raiders from across the Baltic plundered Kongahälla and the reliquary was taken to the cathedral in Cammin in Poland. There another legend grew up around the box, where it was held to contain the bones of St Cordula and became known as the 'Cordula casket'.

The casket was later destroyed in 1945, during the final stages of the Second World War.

Another legend known throughout the Christian world during the Viking Age was that of the Holy Lance, also known as Christ's spear or the javelin of Longinus. This was the weapon thrust into Christ's side by a Roman soldier during Christ's crucifixion on Golgotha. The 'original' can still be seen in Vienna today, although analysis has dated it to the late AD 600s.

This same legend may also have inspired the master smith who created and ornamented the cross-adorned spear from Gotland, Sweden, on the left.

Opposite: Spearhead (iron, silver, gold, copper)

Found in a grave in Klinta, Follingbo, Gotland, Sweden, this spearhead has a cross of silver and gold inlay on its neck.

The Swedish History Museum (SHM 10194)

Right: Cross, encolpion (silver)

This hoard find came from Dörby, Norra Möckleby, Öland, Sweden. It was worn in a long chain around the neck and contained a small relic.

The Swedish History Museum (SHM 1672:5)

Below: Relic shrine (replica)

The original had ornamentation in Mammen style.

The Swedish History Museum (SHM 32080)

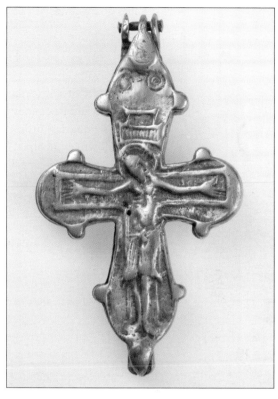

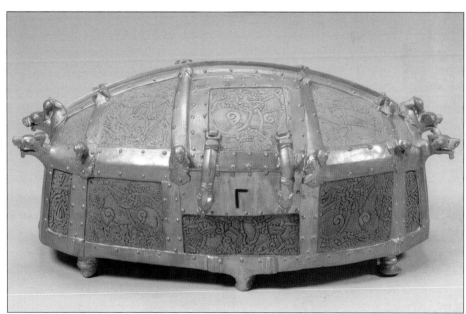

The Old Norse Pantheon

Button-on-bow brooch (bronze, gold and garnet)

Possibly a representation of the goddess Freyja's magic jewel Brisingamen. See page 43.

The Swedish History Museum (SHM 20550:159)

No original sources exist that describe pre-Christian belief systems and gods during the Viking Age. The most detailed account was written later by the Icelandic chieftain and poet Snorri Sturluson, around 1220–30. In a work that was called *Edda*, he described the Old Norse pantheon and the Old Norse concept of the creation of the universe. Snorri's *Edda* is usually known as *The Prose Edda* or *Younger Edda*.

Snorri was a Christian man who lived in a Christian society several centuries after the religion he wrote about was practised. This must have influenced his account. Neither he, nor his contemporary chroniclers, would have been expected to have a complete understanding of the older belief system and the emotions evoked in those who practised these beliefs. Snorri's own Christian belief system is clearly expressed in his *Edda*. When he talks of the gods, for example, they are described as having a different morality – especially the goddess Freyja, who is often referred to in negative terms as licentious, deceitful, skilled in magic, and so on.

We must therefore take Snorri's account with a 'pinch of salt' and analyse the meaning of what he tells us in the context of the world in which he lived.

According to Snorri, the supernatural world was populated by two main types of mythological beings – gods and giants. There were also the Norns (the Fates Ursðr, Verðandi and Skuld who could spin, measure and cut a person's life-thread), the elves, *dísir* and the dwarves. While the first three were strongly connected to the gods, the dwarves were more closely associated with the giants.

There were two kinds of gods – the Aesir and Vanir – who lived in Asgard. The giants lived outside the world of the gods, in Jötunheimr.

Most of the gods and goddesses were of the Aesir race. There were only three Vanir who lived in Asgard – Njord and his children Freyr and Freyja. According to Snorri, the Aesir had originally lived alone in Asgard. The Vanir had been brought there as hostages after a war between the clans of gods.

The pantheon bears a striking resemblance to the human world. The central characters are complex and split according to their characteristics. The over-arching theme in many of the stories is the antagonism between chaos and order as the gods, with Thor as their champion, endeavour to keep the forces of chaos – represented by the giants or any of the monsters created by them – at bay.

The myths can be read and understood as poetic symbols representing the struggle of mankind to find order and meaning in life, and the struggle against destructive forces that threaten their fragile security.

According to one theory, the myth that describes the war between the Aesir and Vanir is really about the contradictions in the worldly society between the ruling minority (aristocracy) on the one hand, and the masses, the majority of the people, on the other.

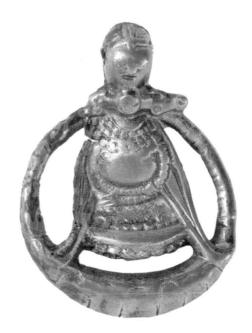

Pendant, Freyja (silver)

This small silver pendant depicting a pregnant woman was found in a richly-endowed grave of a woman from central Sweden. A penannular brooch held her cloak together, with a row of six pearls strung across the chest. It is thought that the pendant represents the goddess Freyja, with her magic jewel Brisingamen. From Aska, Östergötland, Sweden.

The Swedish History Museum (SHM 16429)

The Aesir – gods of the aristocracy

The Aesir had very complex characters, which, among other things, was reflected in their ability to change shape and to transform into animals.

Odin

God of war, knowledge and death, Odin was the most powerful among the Aesir gods and known as the god of the upper class of society. With his brothers Vili and Vé, he created the world out of the body of the giant Ymir. Odin had only one eye – he sacrificed the other one to gain the gift of wisdom.

It was said that Odin hanged himself from the world tree Yggdrasil for nine days and nights in order to learn the runes.

Odin is the main character in many of the songs in *The Poetic Edda* and is also described in great detail by Snorri Sturluson. Said to be very promiscuous, Odin bore children with Asynjur (female Aesir) and giantesses. He seduced, among others, the giantess Gunnlöð, in order to acquire the Mead of Poetry.

At the centre of Asgard was Valhalla, the realm of death for warriors and the aristocracy. In the hall of the fallen, Odin received half of the dead warriors of battle, those chosen by the Valkyries. Valhalla was said to have 540 doors, each one wide enough to allow 800 warriors to walk through side by side.

Odin's ravens, Hugin (thought) and Munin (memory), acted as his spies, and

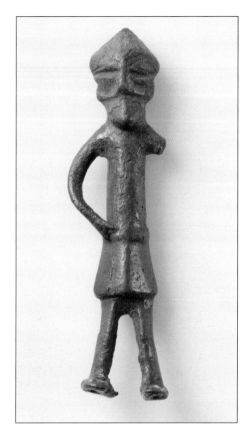

Figurine (bronze)

This small figurine from Lindby, Svenstorp, Skåne, Sweden, depicts a one-eyed man, generally accepted to be a representation of the god Odin.

The Swedish History Museum (SHM 13701)

his eight-legged horse was known as Sleipnir. Odin carried a lance that was called Gungnir.

Odin's name survives in the word 'Wednesday' (Wotan's day, from the older Germanic name for Odin).

Frigg

The Valkyrie Frigg was married to Odin and was the mother of eight children. Frigg is the patron of marriage and motherhood, despite sometimes being unfaithful herself.

Frigg commanded the Valkyries. She had a cloak of falcon feathers with which she could move swiftly through the air. Similar to the Vanir goddess Freyja, Frigg was a magician who had mastered the art of prophecy. Her dwelling is known as Fensalir (Fen Halls).

Friday is possibly Frigg's day or Freyja's day.

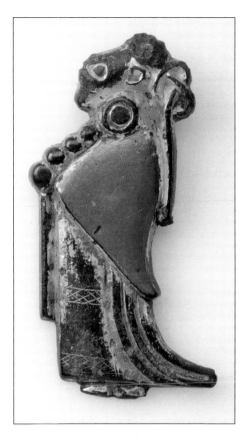

Pendant, female figurine (silver, gilded)

This figurine may depict Frigg, the most powerful of the Asynjur (female Aesir). A grave find from Tuna, Alsike, Uppland, Sweden.

The Swedish History Museum (SHM 10035:111)

Thor

Thor was the god of war and the creator of thunder. One of Odin's sons, he was impulsive and excitable, with incredible strength, thirst and appetite. Although his temper was violent, he was considered to be fair.

Thor lived in a part of Asgard called Thrudvang, in a hall called Bilskirnir.

He had several magical attributes. In addition to his hammer, Mjölnir ('the crusher'), Thor owned a powerful belt, Megingjörð, which, when worn, made him twice as strong. He also had a large pair of iron gloves that helped him to grasp Mjölnir.

In Thor's constant struggle against chaos – whether facing giants, monsters or other dangers – he was held to be the chief protector of gods and humans.

It is clear from sources, archaeological and literary, that Thor was revered and cherished throughout the North, particularly during the latter stages of the Viking Age.

As well as ruler of weather patterns such as thunder, lightning and rain, Thor

was known for fertility. Married to Sif, with whom he had a son, Modi, and a daughter, Thrud, he also had stepsons and 18 'illegitimate' children with a number of giantesses.

Thor, the god of thunder ('donner') lends his name to Thursday and his popularity is obvious from the many examples of his hammer, Mjölnir, that have been found – both as an individual artefact and on pendants.

Miniature Thor's hammer (amber)

From Birka, Adelsö, Uppland, Sweden.

The Swedish History Museum (SHM 35000)

The Vanir – gods of the people

The Vanir were fertility gods who were held hostage in Asgard after the war between the Aesir and the Vanir at the beginning of time. There were only three Vanir – Njord and his two children, son Freyr and daughter Freyja.

Figurine of Freyr (bronze)

This phallic figurine is generally accepted to be a representation of Freyr. From Rällinge, Helgarö, Södermanland, Sweden.

The Swedish History Museum (SHM 14232)

Freyr

Freyr was the brother of Freyja and god of peace, love, sowing and harvest. His abode was called Alfheim. A god of fertility, Freyr was always ready for love. He pined for the giantess Gerd, whom he finally seduced using cunning and magic. The result of this union was his son, Frode. (According to Snorri, Frode became king in Uppsala and father of the Swedish royal house.)

Freyr possessed an enormous ship known as Skiðblaðnir (see page 60). He also had a horse called Blóðughófi ('Bloody Hoof') and a golden boar called Gullinbursti.

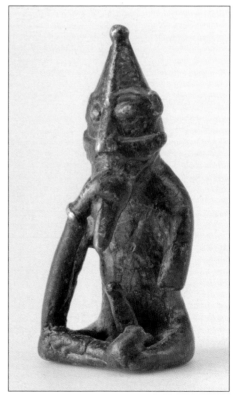

Freyja

Freyja, sister of Freyr, was the most important fertility goddess. Worshippers turned to her during pregnancy and childbirth. A member of the Vanir clan, she was a skilful magician who ruled over life and death. She taught the Aesir to see into the future.

Freyja had reputation for being outspoken, independent and promiscuous. Giants and dwarves were said to desire her. She possessed a magical piece of jewellery, Brisingamen, acquired by sleeping with the four dwarves who forged it.

She was said to be Odin's lover.

Freyja was also a goddess of battle and considered to be the chief of the Valkyries, who chose the other half of the fallen warriors on the battlefield for Freyja. These warriors were received in her home, Fólkvangr, an Old Norse word for 'the Warriors' Plain' or 'the People's Field'. Freyja owned a beautiful hall there, known as Sessrumne.

Freyja often travelled in a chariot drawn by cats – she was referred to as 'the tom-cat owner' by Snorri. Other names for her include Mardöll, Hörn, Gefn and Syr.

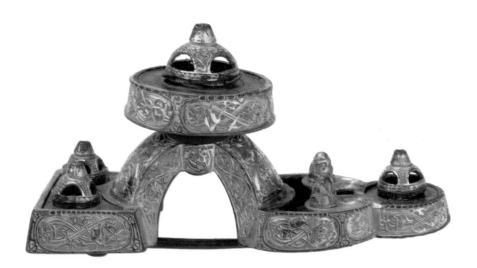

Button-on-bow brooch (bronze, gold and garnet)

Brooches of this kind may be interpreted as a representation of Freyja's jewel Brisingamen. A grave find from Stora och Lilla Ihre, Hellvi, Gotland, Sweden.

The Swedish History Museum (SHM 20550:159)

Valkyries

Pendant, Valkyrie (silver)

A silver mount grave find from Birka, Adelsö, Uppland, Sweden.

The Swedish History Museum (SHM 34000:Bj825)

The Valkyrie was a mythological female figure who appears to have had links with both the mythological Norns as well as the worldly Völur and aristocratic women. The Valkyries were Odin's servants in Valhalla, who were dispatched, armed and mounted, to the scenes of battle to select those who would die in combat. They were thus a kind of goddess of death.

One of the most dramatic descriptions of Valkyries in Norse literature can be found in 'The Spear Song', in the final chapter of Njáls saga. As with the Norns, who are described as spinning (and cutting) life's thread, the otherwise peaceful handicraft of weaving becomes, in the hands of the Valkyries, a poetic metaphor for the ability to influence battles and the fates of warriors.

Below there is a description of how twelve Valkyries weave together the outcome of a battle. Their loom is shocking to look at – the warps are made of human intestines, while decapitated heads are used as loom weights. To tighten the weave, the Valkyries use a bloody spear. An arrow serves as the shuttle, and the weaving batten is a sword.

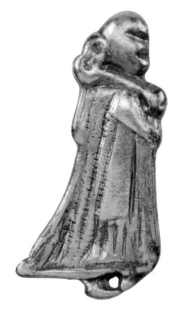

Let us now wind
The web of war
Where the warrior banners
Are forging forward
Let his life
Not be taken
Only the Valkyries
Can choose the slain.

Viking Age representations of Valkyries can be found on picture stones, and as small mounts attached to clothing or pendants. On picture stones Valkyries are shown with drinking horns in hand, welcoming fallen warriors of battle, or Odin himself, as they arrive in Valhalla.

When Valkyries are depicted on jewellery, such as pendants, there are variations that feature them with and without drinking horns. Such jewellery has only been found in the graves of aristocratic women, further illustrating the close connection between the mythological Valkyries and the real-life Lady of the House. In Valhalla, the Valkyries receive the fallen warriors; in the earthly ceremonial hall, women of rank would proceed forward with a goblet of welcome in hand.

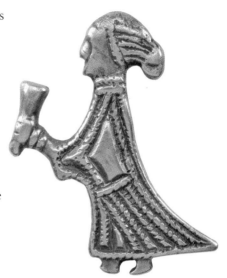

Left: Weaving sword (iron)

From an unknown find-spot, Sweden.

The Swedish History Museum (SHM 3937)

Drinking horn (replica), with mouth mounting (silver and horn)

A grave find from Birka, Adelsö, Uppland, Sweden.

The Swedish History Museum (SHM 34000:Bj 523)

Above: Mount, Valkyrie (silver)

From Klinta, Köping, Öland, Sweden.

The Swedish History Museum (SHM 128)

45

Viking Age art and ornamentation

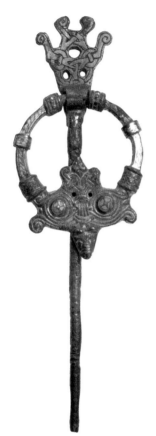

Above: Ring-headed pin brooch (bronze, gold, silver)

This brooch has gripping beast ornament in Borre style (see style 2). The ring and head of the bronze pin are made of silver. The head of the pin is shaped as a bearded demon face. From Alkvie, Endre, Gotland, Sweden.

The Swedish History Museum (SHM 1265)

The gripping beast motif

Art during the Viking Age was primarily decorative and used to ornament a variety of objects. The main motif was a highly stylized animal, sometimes combined with human-like facial features. This motif had a common basis, but over time different styles emerged.

There were six styles of Viking Age art – Oseberg/Broa, Borre, Jellinge, Mammen, Ringerike and Urnes. Each style was named after the place where objects ornamented in that particular style were first encountered. Viewed over time, the styles form a chronological sequence, but one where each style and its successive style overlap. Mixed styles also occur and are not unusual.

1. Broa-style oval brooch
The Swedish History Museum (SHM 39381)

2. Borre-style round brooch
The Swedish History Museum (SHM 416194)

The Oseberg/Broa style is the oldest. It was used as early as the mid-AD700s and peaked during the first half of the 800s. The latest style is the Urnes, used from the middle of the 1000s. The earlier styles – Oseberg/Broa and Borre – are those that feature the classic examples of the gripping beast motif.

The gripping beast ornamentation was based on and developed from animal ornamentation on the continent, which occurred as early as AD400–500. Over time it went from being a northern European continental style to a purely Scandinavian style of art. From the 700s onwards it was found almost exclusively in the Nordic region.

A fundamental feature of such ornamentation is that the animal in question has been divided up before being bound together and intertwined in patterns of varying complexity. It is obvious that the intention was not to achieve a faithful likeness, and one can only wonder why such an abstract form was preferred to a more natural-looking one.

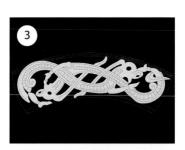

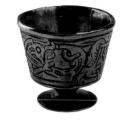

3. Jellinge-style cup
The Swedish History Museum (SHM 181621)

4. Mammen-style fragments
The Swedish History Museum (SHM 986787 and 986892)

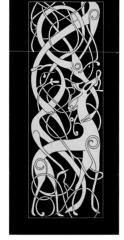

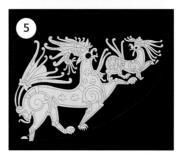

5. Ringerike-style stirrup, mount
The Swedish History Museum (SHM 884084)

6. Urnes-style brooch
(SHM 107297)

Jewellery

Viking Age craftsmen created exquisite gold and silver objects such as bracelets, neck-rings, brooches, belt buckles and accessories. These proclaimed the status of the nobility and aristocracy. The craftsmen mastered all processes from casting and forging, to gilding bronze and applying filigree (when small threads of gold and/or silver are soldered to the base metal). As the work was carried out in dark, indoor environments, the results are all the more impressive.

In order to achieve the desired precision in their work, craftsmen used polished rock crystal lenses as magnifying glasses. Much of what was done by these craftsmen is of such a high quality that it is difficult to reproduce in the modern day.

Penannular brooch with animal-headed terminals (bronze, silver)

This brooch is covered with thin silver plates and decorated with niello work. The terminals are heads of beasts, grinning and bearing their teeth. From Roma monastery, Gotland, Sweden.

The Swedish History Museum (SHM 9391:1)

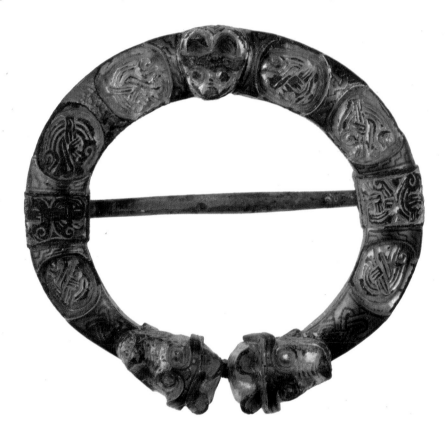

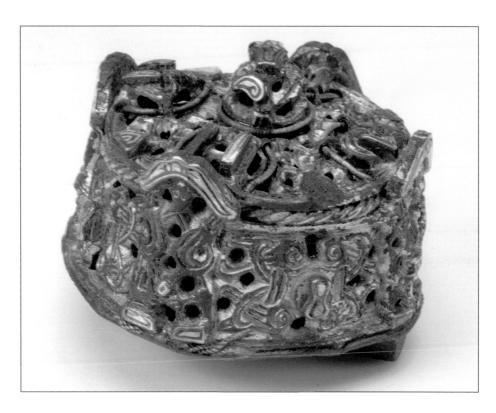

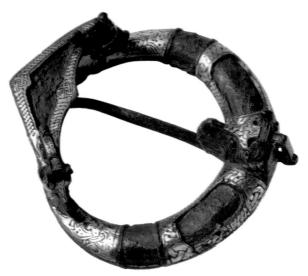

Above:
Box-shaped brooch (bronze, silver, gilded)

Along the bottom and on the top there is filigree-work in silver. A grave find from Slite, Othem, Gotland, Sweden.

The Swedish History Museum (SHM 15752:6)

Left: Penannular brooch (bronze, silver and glass)

There is an animal head in the centre of this brooch. Both eyes were originally made of glass, but only one is preserved. From Tomta, Rone, Gotland, Sweden.

The Swedish History Museum (SHM 10459:1)

Weapons

Norse craftsmen were also involved in the manufacture of weapons, although it is not possible to distinguish between a blacksmith and a highly skilled engraver – the skills were quite different, but they were probably one and the same person.

The sword was the most prestigious weapon of all. Even the most simple of swords had to be manufactured by a skilled blacksmith. The highest quality sword blades were often 'damasked' or pattern-welded. Strips of iron of different qualities were forged together to produce blades that were both strong and flexible, but could retain a sharp edge. When such a blade was polished, a beautiful and intricate surface pattern would emerge. Particular care was taken with the scabbard of the sword. Many were decorated with ornamented detailing in precious metals or bronze.

Spears too might be decorated with geometrical patterns, although it was usually the socket that was ornamented. This could be created either with a relief pattern directly onto the iron surface, or by inlaying. Inlaying involved 'ruffling' the surface of the iron with narrow grooves and hammering fine threads of silver, copper or brass into the grooves.

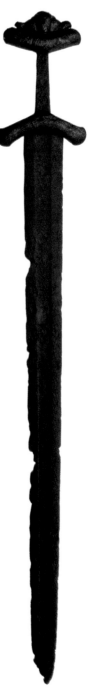

Below: Sword hilt (iron, brass, bronze, silver)

The hilt and pommel are decorated with a rhomboid pattern with silver, bronze and brass. The location of the find-spot is unknown.

The Swedish History Museum (SHM 99)

Right: Sword (iron, silver)

The pommel of this sword is decorated with silver inlay. A grave find from Bengtsarvet and Härvadsarvet, Sollerön, Dalarna, Sweden.

The Swedish History Museum (SHM 22293:1)

A geometric pattern was created using threads of different colours. Another method was to cover the entire surface with hammered silver, which would then be engraved before being filled with a black mixture called niello, made from copper, silver and lead sulphides.

However, most weapons were made to be functional and were less expensively decorated. It mattered more that they were good enough for combat. Nonetheless, many have quite artistic designs.

The importance of weapons is evident from the fact that they were often given proper names. The spear of the god Odin was called Gungnir, and the Viking hero Sigurd Fafnesbane named his sword Gram.

Axe (iron)

This axe head is decorated with vegetal motifs. From Rommunds, Gammelgarn, Gotland, Sweden.

The Swedish History Museum (SHM 8010)

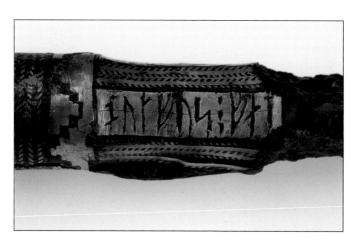

Above and left (detail): Runic spear (iron, silver)

On two sides of the silver-plated socket are runic inscriptions that read, 'Rane owns this spear' and 'Botfus carved'. From Stor-Vede, Follingbo, Gotland, Sweden.

The Swedish History Museum (SHM 15928)

Norse craftsmanship

Rituals and beliefs

There were a number of rituals and beliefs that were strongly associated with craftsmanship during the Viking Age, mostly in the case of metalwork. In the Voluspá prophecy in *The Poetic Edda*, it was noted that the Aesir gods 'smithed'. To 'smith' in this context means to 'create' or to 'manufacture'.

If the gods were considered to be craftsmen in one way or another, is it possible that craftsmen might be considered gods? As the term 'god' refers to a being that is not human, and who possesses qualities beyond those of ordinary people, then perhaps it is entirely possible that highly-skilled craftsmen were considered to have divine powers.

The conversion of bog ore to iron, iron to steel, and steel to sharp weapons, was not just a technological process. Such refining and processing were thought to cause some sort of alteration to the world which had been shaped by the gods. The craftsmen thus had to master rituals and were believed to control the forces and powers of the world.

Academics have debated whether smiths and craftsmen were free or unfree within the Viking Age society. This is based upon the assumption that craftsmen led a nomadic existence, travelling from place to play to offer their services to those who paid the most. A nomadic existence, however, would not have required absolute personal freedom.

In the world of mythology, the social status of the smith is more clearly illuminated. The dwarves are considered the best smiths, but they are not masters of their own destinies. Entirely in the service of the gods, manufacturing the gods' most precious possessions (attributes), the dwarves live and work in the mountains, boulders or underground just outside the abodes of the gods.

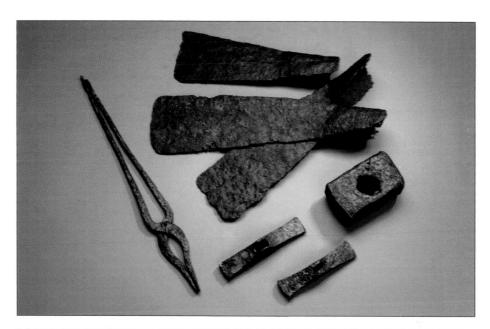

Above: Iron tools

The Swedish History Museum (SHM 1006 and 2297)

Below: Blast pipe (replica)

Mythological motifs were an indication of a ritual aspect to Norse craftsmanship. The myth of Loki is illustrated here. His lips are sewn together as punishment for irritating the dwarf-blacksmiths when they were making attributes for the gods. From Horsens fjord, Snaptun, Denmark.

The Swedish History Museum (SHM 29750:46)

Re-shape, re-model

Craftsmen of the Viking Age were very keen on re-designing, re-forming and re-defining objects. This was especially true when the objects originated from other countries and cultures.

One of the clearest examples of this is the trefoil (three-leaved brooch). In its original Frankish context, it was a 'masculine' object that adorned many sword belts in the Frankish empire. In Scandinavia, however, it became a 'feminine' object, used as a brooch on women's costumes and decorated with animal ornamentation.

Other examples include coins and belt-fittings which were recycled into pendants in beaded embroideries. Silver objects were also melted down to create new pieces, while weights, important to Scandinavian traders, inspired the octagonal shape of the terminals on some penannular brooches (see page 7).

Jugs adorned with crosses

At trading posts such as Birka (located in present-day Sweden), Kaupang (Norway) and Hedeby (northern Germany), the world that surrounded the Norse people made itself known in a number of ways, such as through objects, distinctive burial practices and, not least, through ceramics.

Pottery from the British Isles, as well as from western and eastern Europe, is not unusual at these trading posts. It is possible that many examples were used

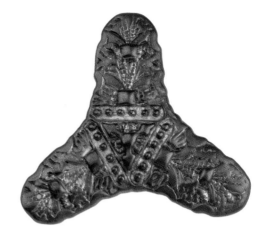

Above: Trefoil brooch (silver, gilded)

This brooch is of European (Frankish) provenance and is decorated with palmettes showing plant-ornamentation popular in the Carolingian Empire. From Väsby, Väsby, Skåne, Sweden.

The Swedish History Museum (SHM 2930:1)

Above: Trefoil brooch (silver, gold)

This brooch is of Scandinavian provenance. The triangular central part was originally filled with gold. It has animal ornamentation in Jellinge-style (see page 47). From Östra Herrestad, Skåne, Sweden.

The Swedish History Museum (SHM 6998:1)

as containers for the transportation of products and objects 'imported' to the trading posts.

A special category of vessel, probably imported for its beauty as a ceramic rather than as a container for transportation, was a type of jug formerly called the 'Frisian jug'. Such jugs were in fact not Frisian but Frankish, and came from the borderlands between present-day Belgium and northern France. Referred to as 'Tating ware', they were made from dark-grey clay and skilfully decorated by the application of thin layers of tin. The decoration on many of the Tating-ware jugs was clearly of a Christian nature, with the foil applied in large crosses over the lower parts of the jug.

It has been assumed for a long time that the cross-adorned Tating-ware jugs played a role in Christian ceremonies, and it has been suggested that they might have contained baptismal water or communion wine. Within the context of Scandinavia, it is thought that the jugs might be associated with the activities of missionaries, although there is no definite evidence for this.

The fact that they were among the possessions of the affluent is, however, not in doubt. Complete Tating-ware jugs have been found in three richly-endowed female graves at Birka (a main trading centre near Stockholm which has been excavated). A jug was found in one of the most exclusive chamber tombs examined on the site, and several shards have also come to light through excavations within the settlement area of Birka.

Birka has plenty of other evidence for early Christian influence, such as the Swedish crucifix thought to be the oldest known example in present-day Sweden (see page 31). As none of the women's graves containing the Tating-ware jugs was a pre-Christian style cremation burial, the context suggests that the jugs may have played a role in the ceremonies of a Christian burial.

A Tating-ware jug from a burial at Birka

This 9th-century 'Tating-ware' type pottery is decorated with thin layers of tin. At the lower part of the jug, motifs of the Christian cross have been applied. With silvery foil applied to the dark-greyish ware, these jugs must have been beautiful when new. Due to centuries of burial underground, much of the former glory of this jug has been lost, but some of the original markings are still visible on its surface.

The Swedish History Museum (SHM 34000:Bj 597)

The living
and the dead

Urn with cremated bones

Grave find from Tureberg,
Sollentuna, Uppland,
Sweden.

The Swedish History Museum
(SHM 29783)

There were two main types of burial in Scandinavia during
the Viking Age: inhumation, where the body is buried directly
in the ground, and cremation, where the body is burned
before burial. The main concept behind cremation or burned
burials is the freeing of the person's soul from the body, so
that it can begin a new existence in the realm of the dead.

There is great regional and local variation within the
tradition of cremation burials, and it is difficult to pinpoint
common practices. Nonetheless, the internal structure of the
graves of ordinary people has been found to be relatively
uniform, giving the impression that certain established
processes or rituals were being followed.

In East Scandinavia, for example, once the flames of the
funeral pyre had died down, the remains of the pyre – burnt
bones of the deceased, sacrificial animals, objects, sooty earth
and pieces of carbon – were gathered together, forming a
thicker, more compact cremation deposit ready for burial.
Parts of the human remains and the rest of the layer's con-
tents were then put into a ceramic urn and placed into the
thickest part of the cremation layer.

The selection of what was included in the urn and
what was left outside was not left to chance. Larger bone
fragments of the deceased and other substantial bones
were chosen for the urn. Smaller bone fragments of
people and animals, and the burnt, melted remains of
combs, beads and personal possessions were left outside.

Combs were particularly important and very few
graves lack a comb. Such items may have been considered
unusable after the deceased had been combed before their
burial ceremony.

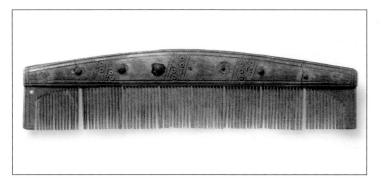

Left, above (burnt comb) and below (unburnt comb)

The burnt remains of the comb (left) show bone/antler and iron elements. The comb below is made from bone/antler and decorated with a dot and circle ornamentation. Both objects come from Birka, Adelsö, Uppland, Sweden.

The Swedish History Museum (SHM 34000:Bj 20 and 35000)

People believed that these rituals had particular purposes and this determined much of what happened at a funeral. The majority of the rituals were intended, in one way or another, to ensure the right outcome, not only for the deceased in their life to come, but also for those still alive.

Burial rituals also provide insight into the life of the deceased. Animal sacrifice is generally considered to be the most common ritual in Viking Age cremation burials and it is found, in one shape or another, throughout Scandinavia. The number of animals and species sacrificed may perhaps indicate higher social status, especially if it involved trained hunting birds and several horses. However,

because animal sacrifice is so common and filled a variety of needs, it is not always a reflection of the deceased's social station. In most cases, the presence of animals represented the belief that contact with 'the other side' could be established through sacrifice.

An East Scandinavian death ritual

At a certain point during the Viking Age, another ritual appeared as part of the burial custom. Not as prevalent as animal sacrifice, it was particularly common in the eastern parts of present-day mid-Sweden and on the island of Åland during the AD900s and 1000s. Although this ritual took place after

cremation, it was still considered part of the burial. A large type of amulet ring, made of iron, would be placed on top of the urn with the burnt remains. On this ring, known as Thor's hammer ring, were one or more miniature hammers and other pendants.

The increase in burials that included amulet rings with Thor's hammer rings during this time, was probably a response to the changing religious situation in the eastern mid-Sweden area and on Åland. Christian missionary activity had begun in earnest during this time and the 'battle for souls' was at its height. The increased ritual use of the rings seems to have been an obvious expression of the cult of Thor as it came under threat from the growing popularity of Christianity.

However, this may not be the entire reason for the presence of the Thor hammer rings in these burials, as other attached pendants may not have had much association with this god. Also, the hammer pendant itself can look very similar to a variant of the Christian cross – the 'T'-shaped Tau cross that is common within the Eastern Roman/Greek Orthodox form of Christianity.

Left: Amulet ring, Thor's hammer ring (iron)

This object has four pendants – two hammers and two rings. A grave find from Väseby, Vallentura, Uppland, Sweden.

The Swedish History Museum (SHM 31461)

**Opposite:
Rivets from a boat**

These iron rivets are a grave find from Ultuna, Bondkyrka, Sweden.

The Swedish History Museum (SHM 11107:3A)

Real and symbolic boats

A very common find in Viking Age cremation burials are the iron clinker nails, used to rivet together the wooden planks of a boat. Sometimes so many rivets are found that it seems possible that the deceased was cremated in an entire boat or ship.

However, when fewer nails are found, it is thought that worn-out boat timbers may have been used for the funeral pyre (tarred wood boat burns well, providing a high rate of combustion), or that the burial boat had been built using mostly saplings and therefore had a more symbolic than practical function.

It is also worth considering that a small quantity of boat rivets in a grave might be fully intentional – burning a boat or a ship may have been an important part of burial practice, but it would clearly have been very expensive. It is thus possible that parts of a boat, such as the rivets, could have been used to represent the whole, creating a kind of symbolic boat burial. If so, this demonstrates how important boats and ships were to Viking Age culture, as a form of transportation in real life as well as a symbolic and psychological gesture.

Boat burials in both burned and unburned forms, real as well as symbolic, have been found throughout Scandinavia as well as on Iceland, although there the boats were never burned. The tradition was used for men and women, young and old, from all social classes.

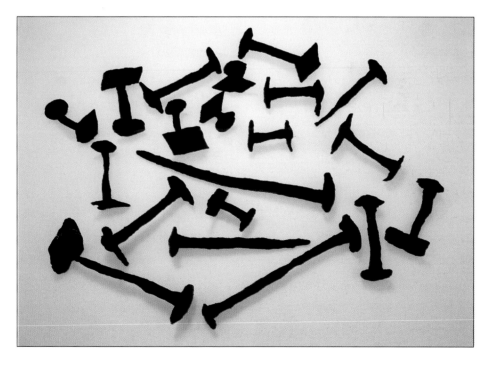

Ships in mythology

Freyr's Skiðblaðnir and the burial of Baldr

Academics have sometimes sought explanation for the Viking Age practice of boat burials from Old Norse mythology – particularly in the case of aristocratic graves, where it is thought a connection to the myths of the gods might exist.

Some have suggested that the practice of boat burials might have had its origin in Viking myth. The god Freyr owned an enormous ship called Skiðblaðnir – large enough to hold all the Aesir gods, yet it could be folded up to fit into a small bag. The ship's ability to sail in a tail-wind meant that no laborious rowing was required.

Connecting the myth of Freyr's ship to the practice of boat burials is, however, not straightforward, as the ship in the myth of Freyr does not play a significant role.

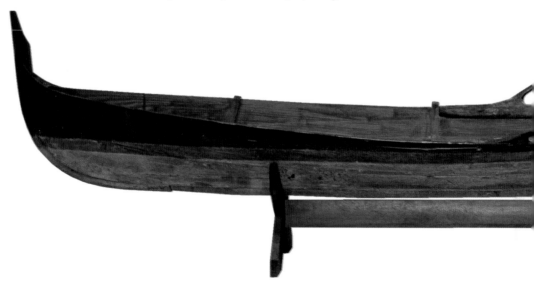

Årby boat (reconstruction)

The original grave where this boat was found dates from AD 850–950. A typical Viking Age rowing boat, it illustrates that both small and large boats were important in burial contexts.

When discovered in 1933, the grave was already plundered. The remaining finds consisted of everyday objects such as household items. A horse and a dog were also among the grave finds.

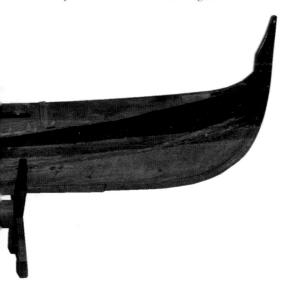

The widespread practice of boat burials may instead have been inspired by the god Baldr and the story that surrounded his funeral and procession. In this tale, the boat or ship was used as a form of transport to 'the other side' and the hope of a return from the world of the dead is featured in the narrative.

The myth tells us that after his death, Baldr was cremated in his ship in the presence of all the other gods.

Mourned by all in Asgard, the gods sent Odin's son Hermod down to the mistress of the realm of the dead, Hel, so that he might retrieve Baldr. Hel made a promise that if the whole world were to weep for Baldr, she would release him.

The sinister Loki, however, who was responsible for Baldr's death, refused to cry anything but dry tears. Baldr thus remained with Hel.

Perhaps the myth's promise of a possible return from the realm of the dead may have made Baldr's particular form of cremation, in a ship, a desirable prospect for others.

Connecting this myth with the popular cremation burial demonstrates how lost beliefs can be reconstructed when we combine the wider social sciences with archaeological evidence. This produces a richer, more detailed picture of the past – taking us beyond the myths and stereotypes of the people we call Vikings.

References

Introduction

Hall, R. 2007. *Stora boken om Vikingarna* [*Exploring the world of the Vikings*]. (Bokförlaget Lind & Co./Thames & Hudson Ltd).

The structure of society

Brink, S. 2003. 'Ambátt, seta, deigja – þræll, þjónn, bryti. Termer för trälar belyser träldomens äldre historia' ['Ambátt, seta, deigja – þræll, þjónn, bryti. Terms for thralls highlighting the older history of slavery'], in T. Lindkvist and J. Myrdal (eds): *Trälar. Ofria I agrarsamhället från Vikingatid till medeltid.* Skrifter om skogs- och lantbrukshistoria 17 [*Thralls. The unfree in agrarian society from the Viking Age to the Middle Ages, Papers on the history of forestry and agriculture*] (Nordiska Museets Förlag).

Strong women

Jesch, J. 1991. *Women in the Viking Age* (The Boydell Press).

Kilger, C. 2008. Kombinationer av föremål – de Vikingatida mittspännedepåerna ['Combinations of artefacts – The Viking Age Centre brooch assemblages'], in K. Childis, J. Lund, J. and C. Prescott (eds): *Facets of archaeology. Essays in honour of Lotte Hedaeger on her 60th birthday*, Oslo Archaeological Series, vol. 10, pp 323–38 (Oslo).

Price, N. 2002. 'The Viking Way. Religion and War in Late Iron Age Scandinavia', dissertation, *Aun* 31 (Uppsala).

More than just worship

Steinsland, G. 1989. 'Religionsskiftet i Norden – et dramatiskt ideologiskifte' ['Religion Shift in the Nordic Countries – a dramatic ideological shift'], in A. Andrén (ed.): *Medeltidens födelse. Symposier på Krapperups borg* [*Birth of the Middle Ages. A Symposium at Krapperup castle*], 1.

Hägg, I. 1983. 'Birkas orientaliska plagg' ['Oriental clothing of Birka'], *Fornvännen* 78, pp. 204–23.

The Old Norse Pantheon

Baeksted, A. 1997. *Nordiska gudar och hjältar* [*Nordic gods and heroes*] (Forum).

Nordberg, A. 2003. 'Krigarna i Odins sal. Dödsföreställningar och krigarkult i fornnordisk religion' ['The Warriors in Odin's hall. What happened after death and the cult of the warrior in Old Norse religion'], Dissertation, University of Stockholm, Department of Religious History.

Näsström, B.-M. 1995. 'Freya – the Great Goddess of the North', dissertation, *Lund Studies in History of Religions*, vol. 5, University of Lund.

Schön, E. 2004. *Asa-Tors hammare. Gudar och jättar i tro och tradition* [*Asa-Thor's hammer. Gods and giants in faith and tradition*] (Hjalmarson & Högberg Bokförlag).

Domeij, M. 2006. 'Att binda djur och väva strid – om djurornamentikens innebörder' ['Binding animals and weaving conflict: On the meanings of animal ornamentation'], in A. Andrén and P. Carelli (eds): *Odens öga – mellan människor och makter i det förkristna Norden* [*Odin's eye – between people and power in the pre-Christian North*], catalogue.

Harrison, D. and K. Svensson 2007. *Vikingaliv* [*Viking Life*] (Fälth & Hässler).

Viking Age art and ornamentation/ Norse craftsmanship

Andrén, A. 2006. 'Människan i Midgård' ['People in Midgard'], in A. Andrén and P. Carelli (eds): *Odens öga – mellan människor och makter i det förkristna Norden* [*Odin's eye – between people and power in the pre-Christian North*], catalogue.

Domeij, M. 2006. 'Att binda djur och väva strid – om djurornamentikens innebörder' ['Binding animals and weaving conflict – on the meanings of animal ornamentation'], in A. Andrén and P. Carelli (eds): *Odens öga – mellan människor och makter i det förkristna Norden* [*Odin's eye – between people and power in the pre-Christian North*], catalogue.

Gansum, T. 2004. 'Jernets fødsel og dødens stål. Rituell bruk av bein' ['The birth of iron and the steel of death. Ritual use of bone'], in Å. Berggren, S. Arwidsson and A.-M. Hållands (eds): *Memory and Myth. The Art of Creating the Past*, Roads to Midgard 5 (Nordic Academic Press).

Gansum, T. 2006. 'Smide och förfädernas ben' ['Smithwork and the Bones of the Ancestors'], in A. Andrén and P. Carelli (eds): *Odens öga – mellan människor och makter i det förkristna Norden* [*Odin's eye – between people and power in the pre-Christian North*], catalogue.

Hed Jakobsson, A. 2003. 'Smältdeglars härskare och Jerusalems tillskyndare. Berättelser om Vikingatid och tidig Medeltid' ['The rulers of the melting pots and promoters of Jerusalem. Stories of the Viking and Early Middle Ages']. Dissertation. *Stockholm Studies in Archaeology* 25.

Hedeager, L. 1997. *Skuggor ur en annan verklighet. Fornnordiska myter* [*Shadows from another reality. Old Norse myths*] (Wahlström & Widstrand).

Ambrosiani, B. 2005. *Birka under Ansgars tid* [*Birka during the time of Ansgar*], Paniba HB (Stockholm).

Gräslund, A.-S. 1996. 'Kristnandet ur ett kvinnoperspektiv' ['Christianity from a female perspective'], in B. Nilsson (ed.): *Christianity in Sweden. Old sources and new perspectives* [Sweden's Christianity Project], publication 5.

The living and the dead

Andersson, G. 2005. 'Gravspråk som religiös strategi. Valsta och Skälby i Attundaland under vikingatid och tidig medeltid' ['Burial customs as a religious strategy. Valsta and Skälby in Attundaland during the Viking and Early Middle Ages'], dissertation, Riksantikvarieämbetet Arkeologiska Undersökningar Skrifter no. 61, Stockholms Universitet.

Svanberg, F. 2003. 'Decolonizing the Viking Age 2. Death Rituals in South-East Scandinavia AD 800–1000', dissertation, *ACTA Archaeologica Lundensia Series* in 40, no. 24.

Ships in mythology

Andersson, G. 2005. 'Gravspråk som religiös strategi. Valsta och Skälby i Attundaland under vikingatid och tidig medeltid' ['Burial customs as a religious strategy. Valsta and Skälby in Attundaland during the Viking and Early Middle Ages'], dissertation, Riksantikvarieämbetet Arkeologiska Undersökningar Skrifter no. 61, Stockholms Universitet.

Clunies Ross, M. 1996. 'Hedniska ekon. Myt och samhälle i fornnordisk litteratur' ['Prolonged echoes: myths and society in Old Norse literature'], *Bokförlaget Anthropos*.

Schjødt, J. P. 1995. 'The ship in Old Norse mythology and religion', in O. Crumlin-Pedersen and B. Munch Thye (eds): *The ship as symbol in Prehistoric and Medieval Scandinavia*, Papers from an International Research Seminar at the National Museum of Denmark, Copenhagen, 5th–7th May 1994. Publications from the *National Museum of Denmark Studies in Archaeology & History*, vol. I (Copenhagen).